THE EARLY WORKS OF J.M.W. TURNER

ISBN 0 905005 91 0
Published by order of the Trustees 1981
Copyright © 1965 The Tate Gallery. Reprinted 1974. Revised edition 1972.
First edition in this format 1981
Designed and published by the Tate Gallery Publications Department,
Millbank, London SW IP 4RG
Printed in Great Britain by Westerham Press, Westerham, Kent

The Early Works of J.M.W. Turner

by Mary Chamot

THE TATE GALLERY

Turner's Early Paintings, 1796–1819

The Tate Gallery has the largest collection of Turner's oil paintings, covering his work from the time he first began to exhibit to the year before his death. His importance as a landscape painter was proclaimed in his life-time by Ruskin with a passionate fervour that few artists have succeeded in arousing among their contemporaries. Today he is admired for quite other reasons and the selection of his work on view differs from the display, restricted to his finished pictures, shown to the public when his bequest came into the possession of the National Gallery in 1856. These facts indicate the breadth of his achievement, for he not only satisfied the romantic taste of his own day, but anticipated the generalized vision of the Impressionists and, however different his aims, even arrived at something like mid-twentieth century abstract-impressionism in the oil sketches, which had never been seen by the public until at least half a century after his death. In fact the immense wealth of the Turner Bequest continues to produce fresh surprises as more canvases are cleaned and put on view.

In the summer of 1931 a large exhibition of Turner's early oil paintings was held at the Tate Gallery, covering the period 1796–1815, and including some pictures from private collections as well as fifty-nine from the Turner Bequest. It was hoped to follow this with an equally full survey of his later work, but for a variety of reasons, culminating in the outbreak of war, this project never materialized, though some sketches were shown in 1939. After the war a representative collection of oil-paintings together with a selection of watercolours was sent to the Venice Biennale in 1948 and toured a number of European capitals, enabling people on the Continent to appreciate his genius for the first time. Since then there have been important exhibitions of paintings from the Turner Bequest in New York, 1966, and Dresden and Berlin, 1972. This activity culminated in the great bicentenary exhibition organised by the Tate Gallery at the Royal Academy in 1974–5, though exhibitions based on the Turner Bequest on a smaller scale continue to be held throughout the world. The Tate Gallery now has three large rooms devoted to the best of the oil paintings, together with a small room devoted to a changing display of watercolours and drawings from the Bequest. Plans are now in hand for the construction of a new gallery to be devoted entirely to Turner,

linked to the Tate but distinct from it; this will be financed by a splendid gift from the Clore Foundation and will be known as the Clore Gallery.

Joseph Mallord William Turner was born in London on 23 April 1775, the son of a barber in humble circumstances, who had a shop off the Strand. He was astonishingly precocious as a child and the earliest dated drawings in the Turner Bequest, now in the British Museum Print Room (T.B. 1), were done when he was only twelve. Like most artists of his day, he learnt to draw by copying the work of others, but by 1789 he appears to have begun the practice he was to continue all his life, of travelling about during the summer making notes from nature in pencil or watercolour, which could be used afterwards as material for pictures. In the same year he entered the Royal Academy Schools, having previously received some instruction from Thomas Malton and Edward Dayes. Probably the most formative influence in these early years was the encouragement of Dr. Munro, who used to invite Turner, Girtin and other young artists to his house and set them to copy his collection of watercolours by J.R. Cozens.

Turner began to exhibit watercolours in the Royal Academy in 1790 and his first oil 'Fishermen at Sea' appeared in 1796 (plate 2). A comparison of the greenish tone of this sea-piece with the more mauve colour of the 'Moonlight: a Study at Millbank', exhibited the following year, reveals his sensitive eye for colour, even in dark night scenes. Turner's subsequent development was a slow but steady progress towards more light and purer colour.

In 1798 he exhibited two views of the Lake District, which he had visited the previous summer, 'Morning among the Coniston Fells, Cumberland' (plate 4), with a quotation from Milton, and 'Buttermere Lake, with Part of Cromackwater, Cumberland, a Shower' (plate 3), with a rainbow and a quotation from Thomson's *Seasons*. During these early years of growing success he was evidently improving his mind by extensive reading, as his schooling had been of short duration. His earnestness of purpose is reflected in the self-portrait (plate 1). At the same time he was exercising his technical resources by painting pictures deliberately in the style of the masters he most admired. He had already visited Wales, probably drawn there by his admiration for Richard Wilson, and he now tried his hand at the Wilsonian style of classical composition in 'Aeneas and the Sibyl: Lake Avernus' (plate 5) as well as painting some views of Welsh scenery and the gracefully designed 'Clapham Common' (plate 6), though this shows less of Wilson's conventions and is more directly based on the actual scene.

In 1799 he was elected A.R.A.; by 1800 he had established himself in Harley Street, where he was to build his own Gallery for periodical display of his latest

works, and in 1802 he became a full member of the Royal Academy. That year Turner went abroad for the first time, when it became possible to do so after the Peace of Amiens. He set out for Paris in July, proceeded to Switzerland via Lyons and Grenoble, toured the regions of Mont Blanc, Val d'Aosta, St. Gothard, Schaffhausen and returned through Nancy to Paris, where he made extensive notes on the old masters assembled by Napoleon at the Louvre. Altogether he filled eight sketchbooks with some five hundred drawings during the tour (T.B. LXXI–LXXXI).

The result of this was a series of pictures more ambitious and varied than he had previously attempted. Vivid memories of his rough Channel crossing inspired him to paint 'Calais Pier, with French Poissards preparing for Sea: an English Packet arriving' (National Gallery). Here and in the 'Shipwreck' (plate 9) exhibited two years later, but probably painted about the same time, his mastery in painting a stormy sea appears coupled with a new and more emphatic use of chiaroscuro, giving drama and depth to the design. At the same time he preserved a delicate juxtaposition of blue, grey, red, mauve and yellow colours in the clothes of the figures.

Turner had seen works by Poussin in English private collections and had exhibited 'The Tenth Plague of Egypt' in 1802. During the next decade he painted several more biblical and classical compositions with emphasis on architectural structure, such as 'The Destruction of Sodom' (plate 8), 'The Goddess of Discord choosing the Apple of Contention in the Garden of the Hesperides' (plate 10), two views of Bonneville, now in private collections abroad, and 'The Vintage at Macon' in the Sheffield Art Gallery. His admiration for Titian found expression in 'Venus and Adonis' (formerly on loan to the Gallery and now in the Huntingdon Hartford Gallery of Modern Art, New York) and in the 'Holy Family' (plate 7), originally also planned as an upright composition with angels above, according to a drawing (T.B. LXXXI). The colour of these pictures has almost certainly darkened with time, but Turner's notes made in the Louvre show him to have been critical of garish colour in many of the pictures he saw. It was only some twenty years later that he himself began to use purer colours and banished the 'gallery tone'. His late figure painting reflects the glowing reds and golds of Rembrandt, but in these early years he confined himself to more sober interiors with figures in the manner of Teniers, possibly in rivalry with Wilkie. 'A Country Blacksmith disputing upon the Price of Iron, and the Price charged to the Butcher for shoeing his Pony' (plate 11), exhibited in 1807, is proudly inscribed: J.M.W. Turner R.A. It is one of the pictures Turner bought back at the De Tabley Sale in 1827, together with 'Sun rising through Vapour' (National Gallery), for

more than he had been paid originally. Hardly any of the pictures in the Bequest bear a signature; probably he was not in the habit of signing his work before it was sold, or unless requested to do so by the purchaser. He now had a growing circle of patrons among whom the third Earl of Egremont remained his lifelong friend. The list of subscribers to the first of his pictures to be engraved, 'The Shipwreck' of 1805, contains many distinguished names.

In addition to classical and mythological subjects he attempted a contemporary historical subject, the death of Nelson, exhibited in his own Gallery in 1806: 'The Battle of Trafalgar, as seen from the Mizen Starboard Shrouds of the Victory' (plate 12). Here he was able to combine his knowledge of shipping with the interest of a topical event, but the picture remained unsold. Many years later in 1823 he was commissioned to paint a large picture of the Battle of Trafalgar for St. James's Palace, now in the National Maritime Museum, Greenwich.

From about 1807 Turner began to exhibit more landscapes of English scenery, though still painting occasional subjects in emulation of the old masters. The landscapes, mostly of the Thames Valley and the Thames Estuary, show a careful study of tone values and atmospheric effects in a higher key and without the heavy contrasts of his earlier compositions (cover and plates 19, 22, 23 and 26). It was probably during the summer of 1807 that Turner made the oil sketches of Thames scenery, evidently direct from nature, from a boat. Some of these are painted on thin mahogany, the reddish wood often showing through the rapidly applied brushstrokes (plate 16). The immediate rendering of the relation of treetops and buildings to skies taught Turner a new understanding of landscape and shows surprising similarities to the almost contemporary sketches by Constable, such as the 'View of Epsom' (Tate Gallery, No. 1818), and also to the somewhat later outdoor work of the French painter Corot. Some of the sketchbooks, filled with drawings and watercolours of the river, are, like the oil-sketches, unusual in their long horizontal shape, so well suited to the subject of a river bank (T.B. XCVI, XCIX, etc.). The son of the Reverend Henry Scott Trimmer, Turner's old friend and executor, has recorded, according to Thornbury, that Turner used to paint large canvases direct from nature from his boat: 'In my judgement these are among his very finest productions: no retouchings, everything firmly in its place . . . This is the perfection of his art, but Turner's mind was so comprehensive that he could not carry out the detail though he was far from despising it.' Plates 14, 15, 18 and 20 are probably among the pictures Trimmer had in mind.

A number of reasons could be put forward for the good fortune that these canvases were never finished. Some were discarded and the subject was repeated

on another canvas (plate 19). Turner was overwhelmed with work during this decade, including commissions for views of country seats, like 'Somer Hill' in the National Gallery of Scotland, and no doubt began more canvases than he would ever have had time to finish. He had just embarked on a new venture to produce a series of engravings which he entitled *Liber Studiorum* and continued to work at until he finally gave up in 1819. The subjects of over a dozen of his earlier pictures were used for some of the plates (see plates 19, 26 and 28) and the project served to give his work a wide publicity. But probably the chief reason why Turner left so many vivid direct studies in their pristine condition is that he realized how much the 'finish' demanded by the public would detract from their quality. The difference seen by a comparison of the sketches (plates 14, 15, 16, 17, 18 and 20) with the exhibited pictures (cover and plates 19, 22, 23 and 26) is even more apparent in front of the actual paintings. The figures in particular, often so inarticulate and blurred in the finished pictures, seem to fit into the landscape better when indicated only by a few apt touches of colour without any attempt at modelling.

The effect of a windswept sea with boats rising and falling is dramatically rendered in the slight sketch 'Shipping at the Mouth of the Thames' (plate 18), probably painted at about the same time as the other Thames sketches, and in the more ambitious blustery sea-piece called, when it was exhibited at the Royal Academy in 1809, 'Spithead: Boat's Crew recovering an Anchor' (plate 13). The title in the Royal Academy catalogue does not indicate the real subject, which represents two of the Danish ships, seized at Copenhagen, entering Portsmouth Harbour. Turner had made a special journey down to see the arrival of the squadron, but it was dispersed by bad weather and he only saw the arrival of two ships, which he recorded in a sketchbook and then developed in the picture. Perhaps it was the topical nature of the subject which led him to exhibit it in 1808 in his own Gallery before it was finished, as he had previously shown his 'Trafalgar'. As a rule he was extremely secretive about the progress and methods of his work and never had any pupils or assistants in his studio. 'Fishing upon the Blythe-Sand, Tide setting in' (cover) is also reminiscent of the Dutch masters but, as usual, shows his own powers of observation in the light and colour playing on the sails and suggesting a breeze.

There seems to be no doubt that the general public appreciated Turner's paintings of familiar English scenery with its diffused light and haze, although the connoisseurs, personified by Sir George Beaumont, carried on a campaign against his endeavour 'to make painting in oil appear like watercolour'. Turner and his followers were dubbed 'the white painters' because they no longer covered their

[8]

paintings with black and brown. One of the most revolutionary pictures in this respect was Turner's 'Frosty Morning' (plate 27) perpetuating a scene he had remembered on a journey to Yorkshire. It is one of the first instances of his abandoning the conventional composition of a dark foreground and a luminous distance taking the eye inward into the centre. Here the spectator is invited to follow two paths diverging sideways, the road on the left with the stage coach in the distance and the gate on the right towards the sun, thus giving a far greater illusion of limitless space. The retentiveness of Turner's memory and the use to which he put effects he had seen is exemplified in the picture 'Snow Storm: Hannibal and his Army crossing the Alps' (plate 25). The mountain setting was based on studies he had made on his first journey to Switzerland, as was also 'The Fall of an Avalanche in the Grisons' (plate 24), but the storm was one he had witnessed while staying with his friend Walter Fawkes at Farnley Hall in Yorkshire.

In 1811 he paid his first visit to Devonshire and went again in 1813. In 'St. Mawes at the Pilchard Season' (plate 21) he found a subject after his own heart and treated it more colourfully than his earlier shipping and harbour scenes. He made small oil sketches as well as watercolours on this tour and the scenery inspired him to paint several pictures in the manner of Claude. This artist does not appear to have evoked any comment from Turner in Paris, perhaps because he had seen better examples in England. In 1814 he exhibited at the British Institution the closest imitation of Claude he ever produced, 'Appulia in search of Appulus – Vide Ovid' (plate 28), a variant of Claude's picture at Petworth of 'Jacob with Laban and his Daughters'. The placing of the trees, the distant hills, the bridge in the middle distance and the figures in the foreground are almost identical, but Turner lacks the lucidity of Claude and suggests a Northern haze rather than the clear Roman light. In the same year in the Academy he showed 'Dido and Æneas', the first of his Carthaginian subjects. 'Crossing the Brook' shown the following year (plate 29) is so Claudian in character that it has often been taken for an Italian scene but is actually a view of the Tamar valley in Devon.

It has been suggested by Thornbury and others that Turner's predilection for Carthaginian subjects may have been due to the patriotic feelings stirred by the Napoleonic wars and to a parallel he saw between the rise of Carthage as a maritime power and that of England. Compositions of classical harbours occur in some of the Thames sketchbooks, but it is not certain whether he spent his evenings while on the river working out these designs or used the blank pages of the same sketchbook years later. In any case it seems that, like so many modern artists, he would visualize a design, put it down on paper, and then find an appropriate title.

Several alternate titles are inscribed on some drawings (T.B. XC). Apart from Virgil, Thomson's poetry served as a source for many of his lectures; his own poetic experiments, *Fallacies of Hope*, quoted in the Academy catalogues, were mainly modelled on Thomson, just as so many of his pictures were at this time on Claude. That he deliberately intended to measure his own achievement against that of the French master is proved by his bequest of two pictures he prized most highly to the National Gallery on condition that they were hung between Claude's 'Seaport' and 'Mill'. One of these was 'Dido building Carthage', which was universally admired when it was first exhibited in 1815. The following year he exhibited 'The Decline of the Carthaginian Empire' (plate 30).

In 1817 Turner made his second journey abroad, this time to Belgium, Holland and up the Rhine, filling his sketchbooks with material for future use, but the only records of this tour in the Gallery are the rather turgid moonlit 'Field of Waterloo', strewn with dead bodies after the battle, and 'Entrance of the Meuse' (plate 31), a stormy sea-piece with a very low horizon-line and a cloud-swept but luminous sky. The most successful work, the famous 'Dort', painted in evident emulation of Cuyp, was sold to Walter Fawkes, Turner's most important patron apart from Lord Egremont, and is now in the Mellon collection. Most of the watercolours recording this tour were also purchased by Fawkes.

During the spring of 1819 two retrospective exhibitions of Turner's work were held. Sir John Leicester, who had also been a regular patron and owned eight of Turner's important pictures, as well as works by his contemporaries, opened his London house to the public, and Walter Fawkes followed suit with a display of over sixty of his finest watercolours. Catalogues were printed of both collections, and these private exhibitions, together with his contributions to the Royal Academy, brought Turner's name prominently before the public. Turner's last two pictures, shown before he set out for Italy in August, were an epitome of his work up to that time, the 'Entrance of the Meuse' as a sea painter and the huge 'England: Richmond Hill, on the Prince Regent's Birthday' (plate 32) as a landscape painter in the tradition of Claude but with contemporary figures and representing an actual scene, so harmonious that it needed no artificial build-up. Perhaps the quotation from Thomson, appended to the title in the Royal Academy catalogue, beginning with the words 'Which way, Amanda, shall we bend our course?' was also significant, pointing to Turner's realization that he had reached a turning point in his career. The experience of Italian light was going to change his whole outlook on landscape, so that all the earlier pictures now seem dark and colourless by comparison. Admittedly some allowance must be made for darkening over the

years, otherwise it would be difficult to account for the complaints of 'more than a natural or allowable proportion of positive colour' levied against 'Richmond Hill' by his contemporaries. The slightly earlier 'Decline of the Carthaginian Empire' (plate 30) shows the use of orange light and violet or blue shadows to suggest relief without darkness, already evident in the distant building of 'Guildford from the Banks of the Wey' (plate 17), but these are only premonitions of the splendid colour and radiance of Turners' later works.

Further Reading

Walter Thornbury *The Life of J.M.W. Turner, R.A.* 1862; 2nd edition 1877.

A.J. Finberg *Turner's Sketches and Drawings* 1910; reprinted with an introduction by Lawrence Gowing 1968.

A.J. Finberg *The Life of J.M.W. Turner, R.A.* 1939; 2nd edition 1961.

Martin Butlin *Turner Watercolours* 1962 and subsequent editions.

Michael Kitson *J.M.W. Turner* 1964.

Lawrence Gowing *Turner: Imagination and Reality* 1966.

Jack Lindsay *J.M.W. Turner, his Life and Work* 1966.

John Gage *Colour in Turner* 1969.

Graham Reynolds *Turner* 1969.

Gerald Wilkinson *Turner's Early Sketchbooks* 1972.

Gerald Wilkinson *The Sketches of Turner, R.A., 1802–20* 1974.

Luke Herrmann *Turner: Paintings, Watercolours, Prints and Drawings* 1975.

Andrew Wilton *The Life and Work of J.M.W. Turner* 1979.

List of Plates

25 *Snow Storm: Hannibal and his Army crossing the Alps* exh. 1812
Canvas, $57\frac{1}{2} \times 93\frac{1}{2}$ (146×237.5) [490]

26 *London* exh. 1809
Canvas, $35\frac{1}{2} \times 47\frac{1}{4}$ (90.2×120) [483]

27 *Frosty Morning* exh. 1813
Canvas, $44\frac{3}{4} \times 68\frac{3}{4}$ (113.7×174.6) [492]

28 *Appulia in search of Appulus* exh. 1814
Canvas, 57×93 (144.8×236.2) [495]

29 *Crossing the Brook* exh. 1815
Canvas, 76×65 (193×165.1) [497]

30 *The Decline of the Carthaginian Empire* exh. 1817
Canvas, 67×94 (170.2×238.8) [499]

31 *Entrance of the Meuse: Orange-Merchant on the Bar, going to Pieces: Brill Church bearing S.E. by S., Masensluys E. by S* exh. 1819
Canvas, 69×97 (175.3×246.4) [501]

32 *England: Richmond Hill on the Prince Regent's Birthday* exh. 1819
Canvas, $70\frac{7}{8} \times 131\frac{3}{4}$ (180×334.6) [502]

Note
The dimensions are given in inches followed by centimetres in brackets; height precedes width.

Note

The Turner collection at the Tate Gallery normally occupies three galleries with an additional gallery devoted to watercolours, mainly selected from those in the Turner Bequest now in the care of the British Museum Print Room. As the selection is changed from time to time references are not to individual examples but to the Roman numerals under which sketchbooks and groups of associated works have been catalogued, for example 'T.B. LXXI'. The Tate Gallery's catalogue numbers of the works reproduced are given at the end of each caption and in the list of plates. In addition to works in the Tate Gallery's own collection mention is made of some in other public collections, particularly the National Gallery with which oil paintings from the Turner Bequest are sometimes exchanged.

A companion volume by Martin Butlin on Turner's later paintings in the Tate Gallery is also available.

A complete catalogue of *The Paintings of J.M.W. Turner* (including all those at the Tate Gallery) by Martin Butlin and Evelyn Joll was published by Yale University Press for the Paul Mellon Centre for Studies in British Art and the Tate Gallery in 1977.

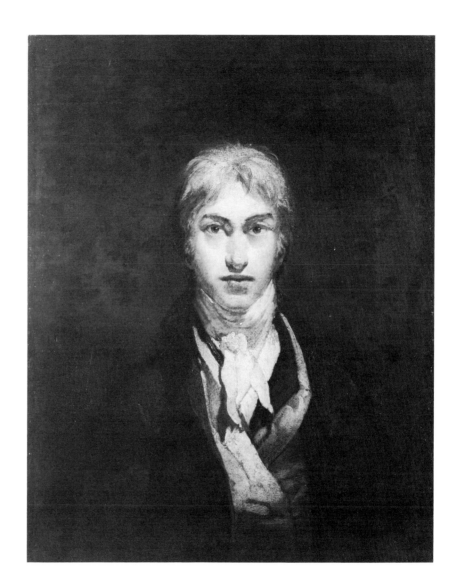

1 *Self-Portrait c.*1798.
 Canvas, 29¼ × 23 (74.3 × 58.4)
 [458]

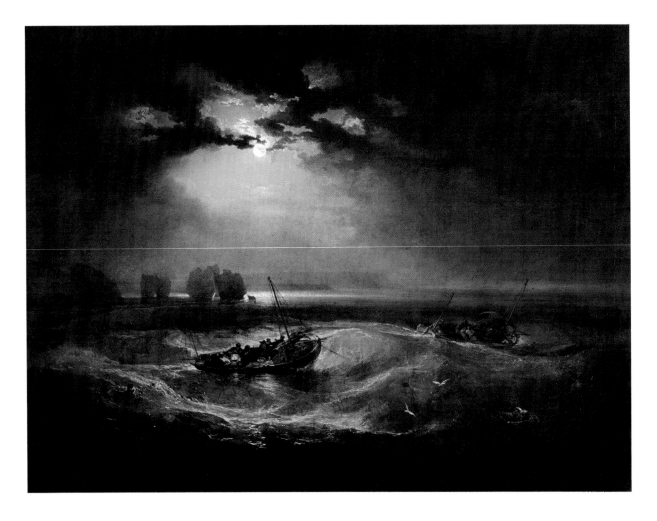

2 *Fishermen at Sea* exh. 1796
Canvas, 36 × 48½ (91.4 × 123.2)
[T.1585]

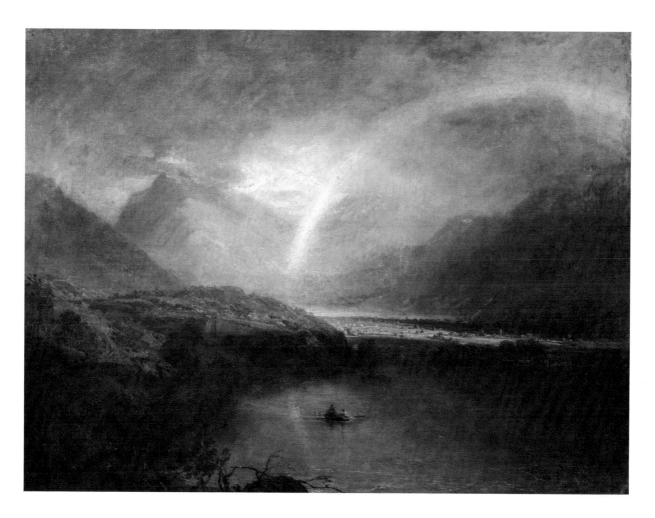

3 *Buttermere Lake, with Part of*
Cromackwater, Cumberland, a Shower exh. 1798
Canvas, 35 × 47 (88.9 × 119.4)
[460]

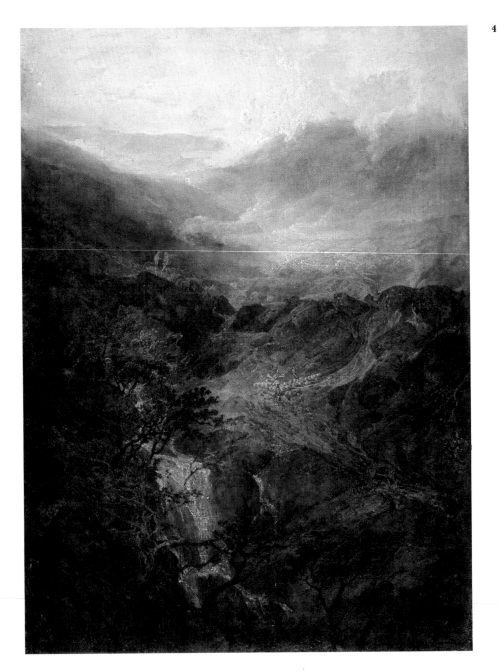

4 *Morning amongst the Coniston Fells,*
Cumberland exh. 1798
Canvas, $48\frac{3}{8} \times 35\frac{3}{8}$ (122.9 × 89.9)
[461]

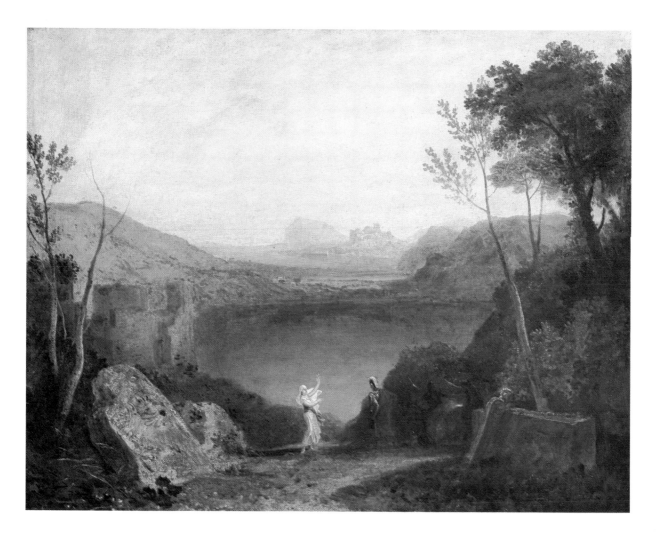

5 *Æneas and the Sibyl: Lake Avernus c.*1798
 Canvas, $30\frac{1}{8} \times 38\frac{3}{4}$ (76.5 × 98.4)
 [463]

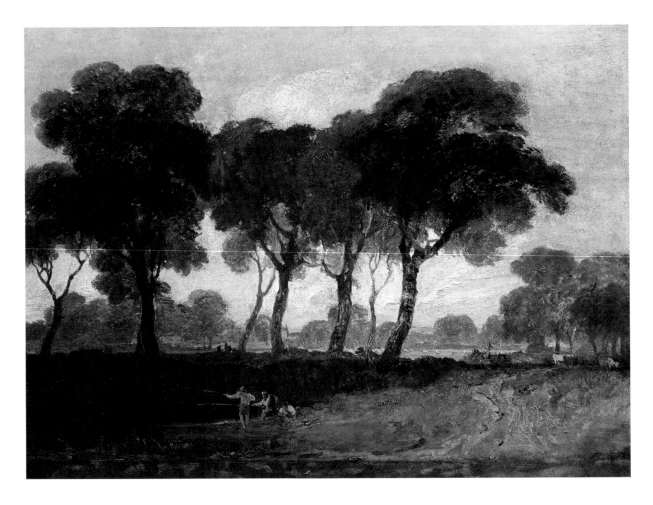

6 *View on Clapham Common c.*1800–5
 Panel, $12\frac{5}{8} \times 17\frac{1}{2}$ (32.1 × 44.5)
 [468]

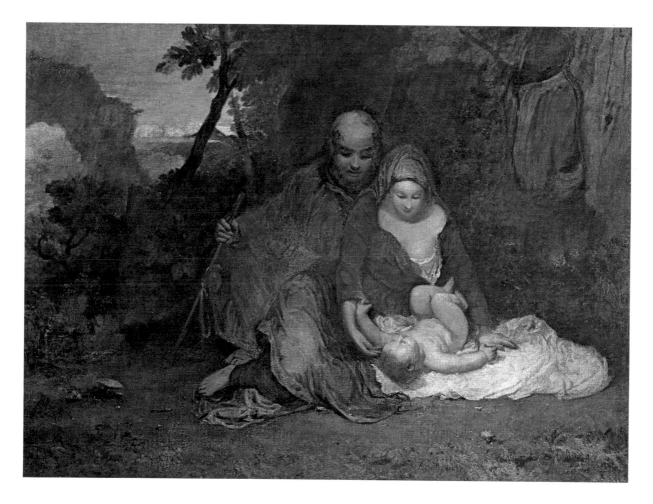

7 *Holy Family* exh. 1803
Canvas, $40\frac{1}{4} \times 55\frac{3}{4}$ (102.2 × 141.6)
[473]

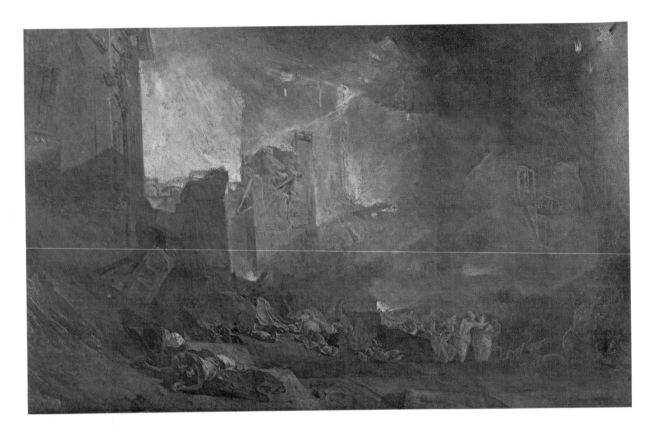

8 *The Destruction of Sodom* exh. 1805?
Canvas, $57\frac{1}{2} \times 93\frac{1}{2}$ (146×237.5)
[474]

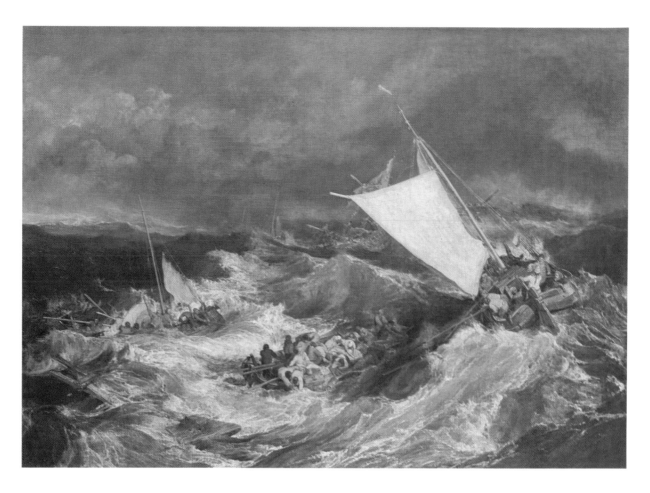

9 *The Shipwreck* exh. 1805
Canvas, $67\frac{1}{8} \times 95\frac{1}{8}$ (170.5 × 241.6)
[476]

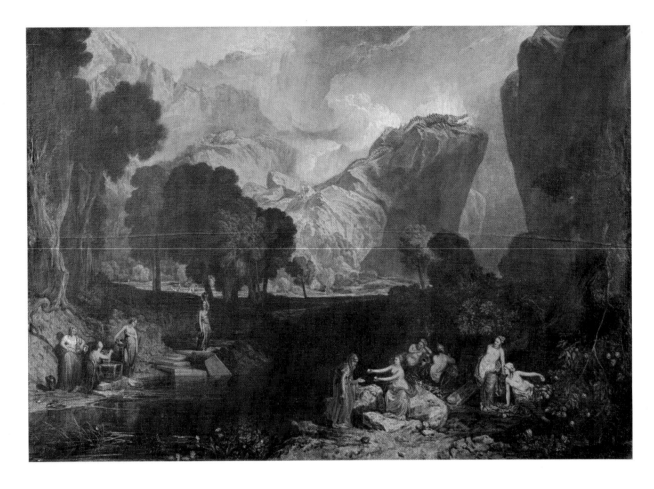

10 *The Goddess of Discord choosing the
Apple of Contention in the Garden of the
Hesperides* exh. 1806
Canvas, $61\frac{1}{8} \times 86$ (155.2 × 218.4)
[477]

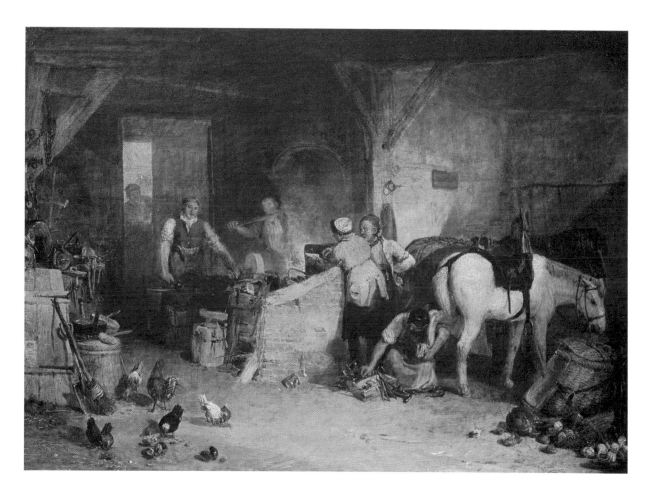

11 *A Country Blacksmith disputing upon the*
Price of Iron, and the Price charged to the
Butcher for shoeing his Pony exh. 1807
Panel, $21\frac{5}{8} \times 30\frac{5}{8}$ (54.9 × 77.8)
[478]

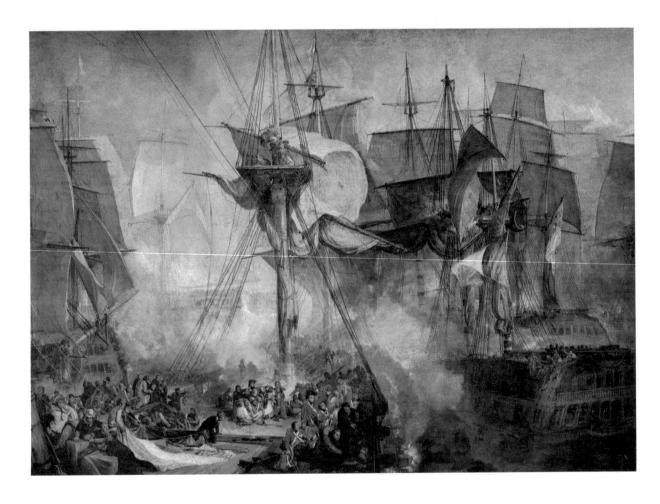

12 *The Battle of Trafalgar, as seen from the Mizen Starboard Shrouds of the Victory* 1806–8
Canvas, $67\frac{1}{4} \times 94$ (170.8×238.8)
[480]

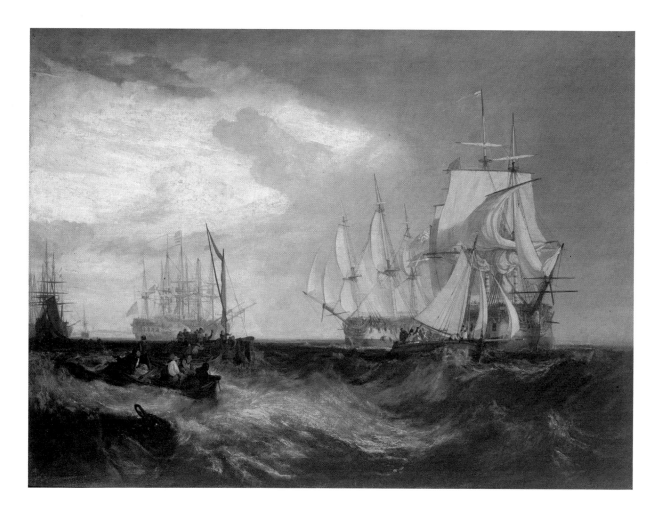

13 *Spithead: Two Captured Danish Ships
entering Portsmouth Harbour* 1807–9
Canvas, $67\frac{1}{2} \times 92$ (171.5 × 233.7)
[481]

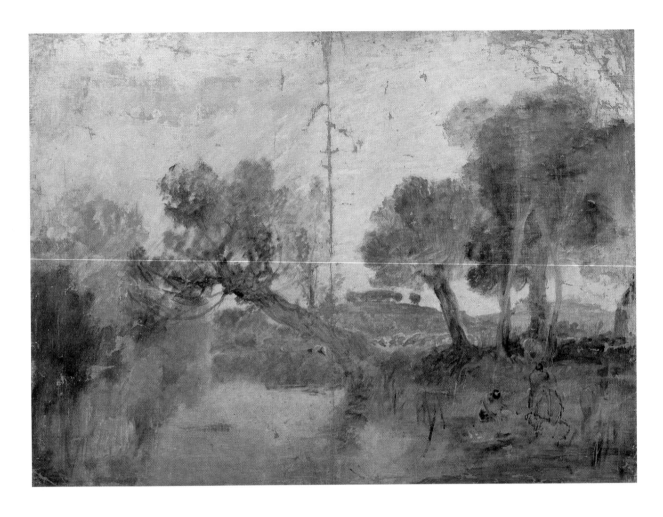

14 *Washing Sheep c.*1806–7
Canvas, $33\frac{1}{4} \times 45\frac{7}{8}$ (84.5 × 116.5)
[2699]

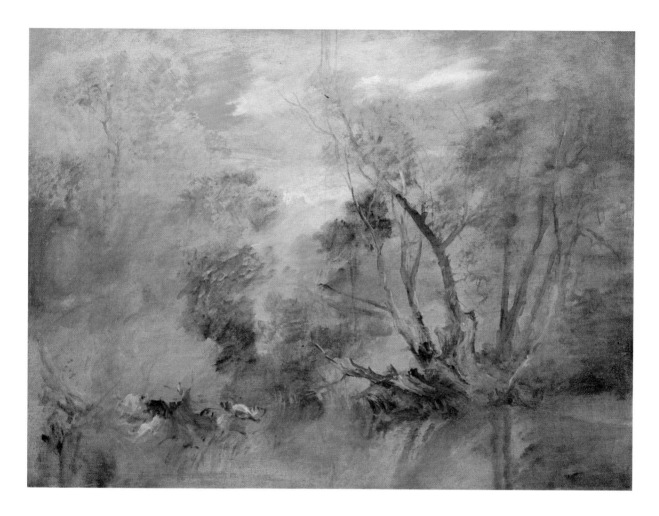

15 *Willows beside a Stream c.1806–7*
Canvas, $33\frac{7}{8} \times 45\frac{3}{4}$ (86×116.2)
[2706]

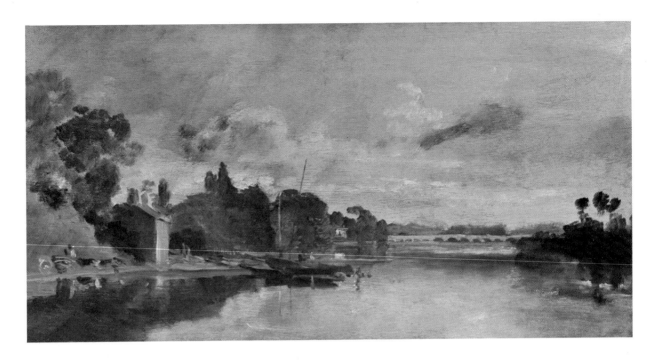

16 *The Thames near Walton Bridges* c.1807
Panel, $14\frac{5}{8} \times 29$ (37.1×73.7)
[2680]

17 *Guildford from the banks of the Wey*
c.1807
Panel, 10 × 7¾ (25.4 × 19.7)
[2310]

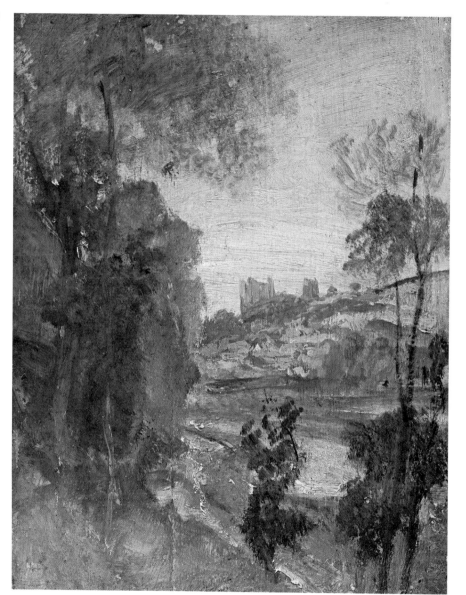

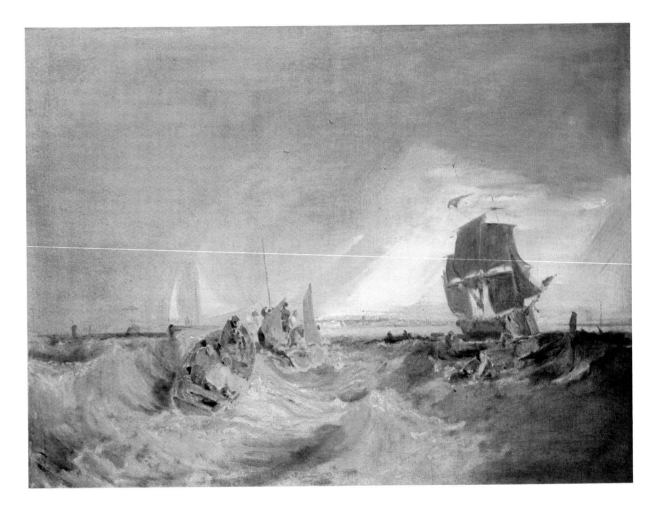

18 *Shipping at the Mouth of the Thames c.*1806–7
Canvas, $33\frac{3}{4} \times 46$ (85.7 × 116.8)
[2702]

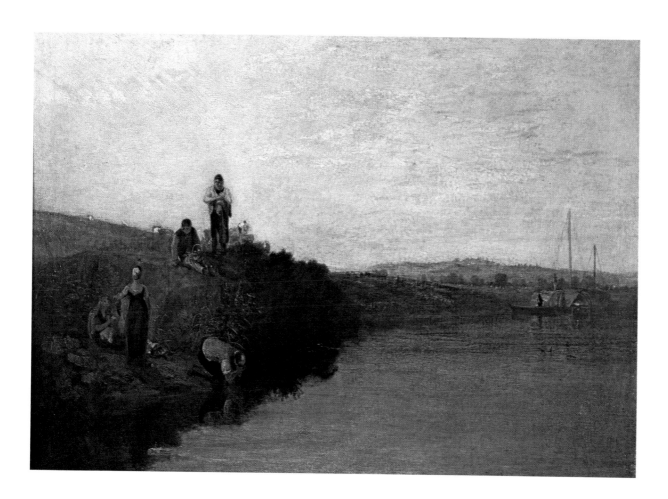

19 *Harvest Dinner, Kingston Bank* exh. 1809
Canvas, $35\frac{1}{2} \times 47\frac{5}{8}$ (90.2 × 121)
[491]

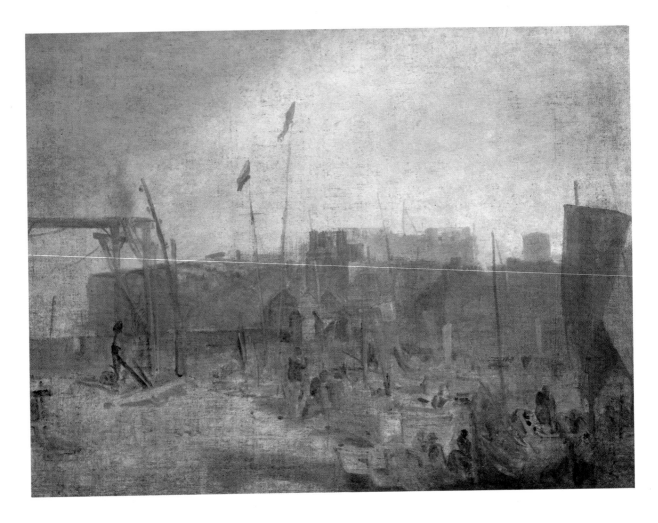

20 *Harbour Scene, probably Margate c.*1806–7
Canvas, $33\frac{3}{4} \times 45\frac{3}{4}$ (85.7×116.2)
[2700]

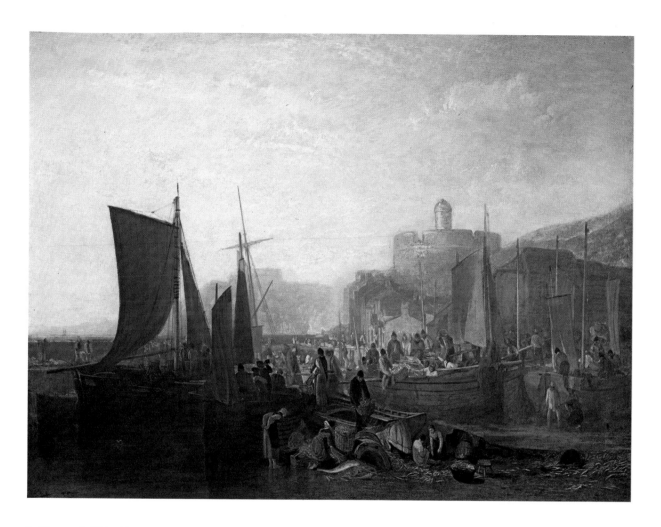

21 *St. Mawes at the Pilchard Season* exh. 1812
Canvas, $35\frac{7}{8} \times 47\frac{1}{2}$ (91.1 × 120.7)
[484]

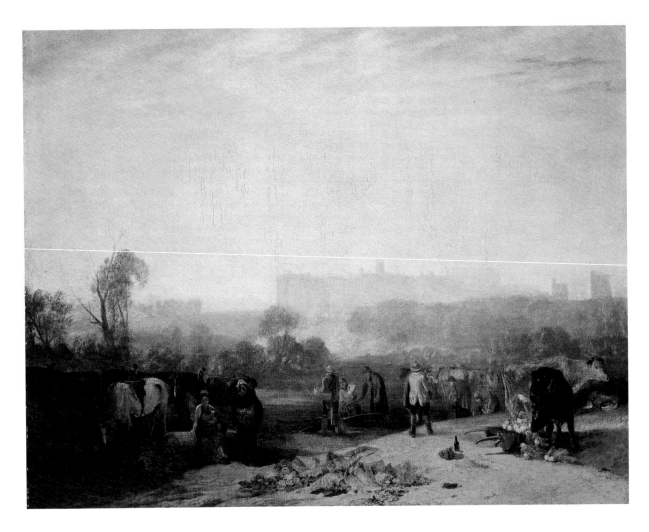

22 *Ploughing up Turnips, near Slough*
('Windsor') exh. 1809
Canvas, $40\frac{1}{8} \times 51\frac{1}{4}$ (101.9 × 130.2)
[486]

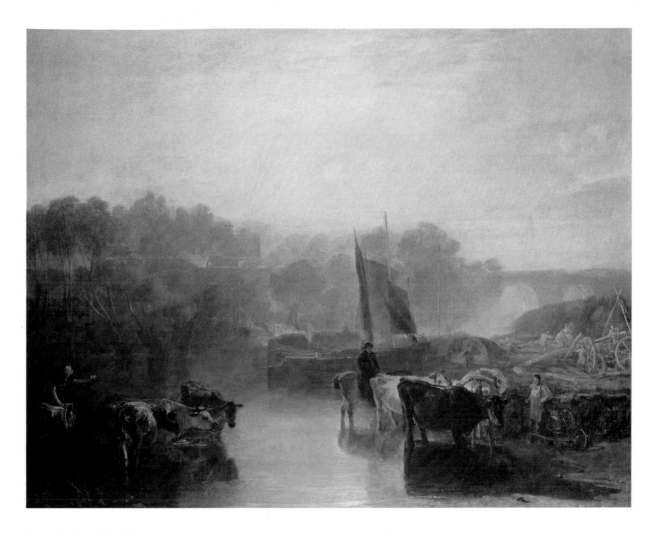

23 *Dorchester Mead, Oxfordshire*
('Abingdon') exh. 1810
Canvas, 40 × 51¼ (101.6 × 130.2)
[485]

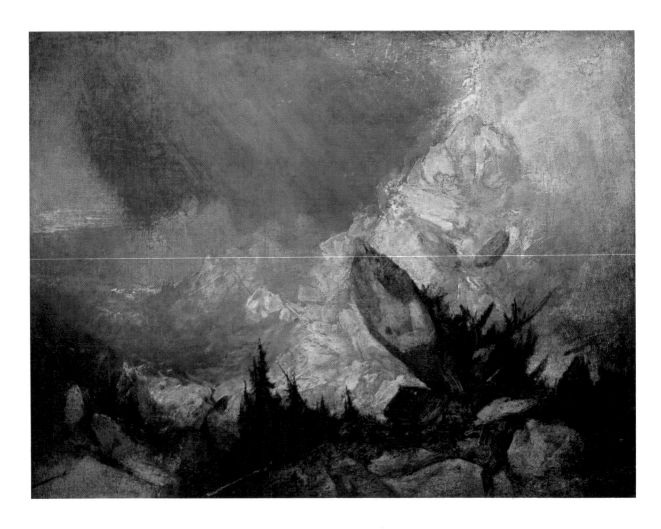

24 *The Fall of an Avalanche in the Grisons* exh. 1810
Canvas, $35\frac{1}{2} \times 47\frac{1}{4}$ (90.2 × 120)
[489]

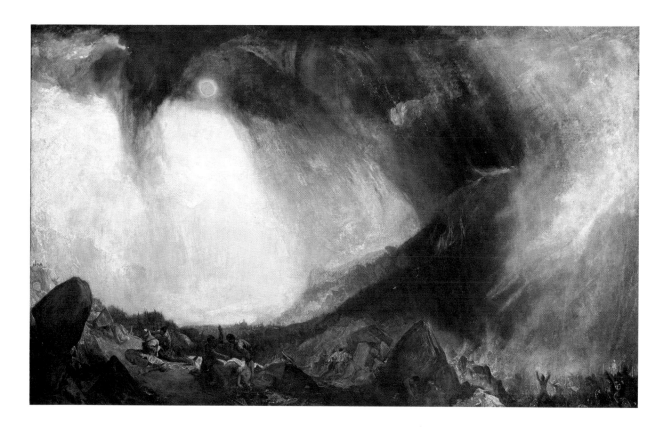

25 *Snow Storm: Hannibal and his Army*
crossing the Alps exh. 1812
Canvas, $57\frac{1}{2} \times 93\frac{1}{2}$ (146×237.5)
[490]

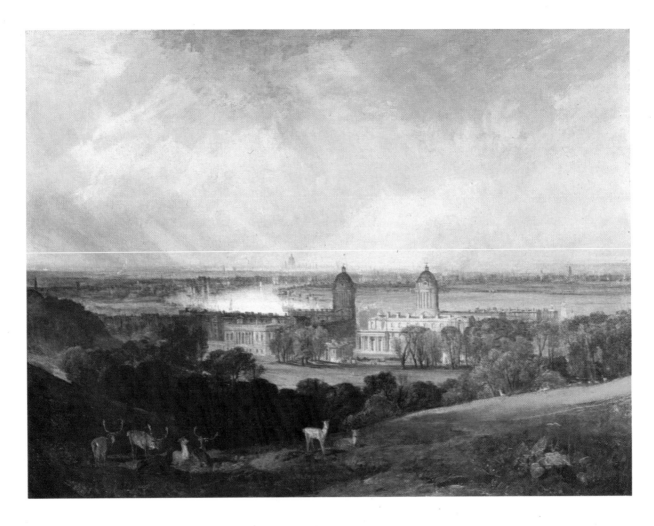

26 *London* exh. 1809
Canvas, $35\frac{1}{2} \times 47\frac{1}{4}$ (90.2 × 120)
[483]

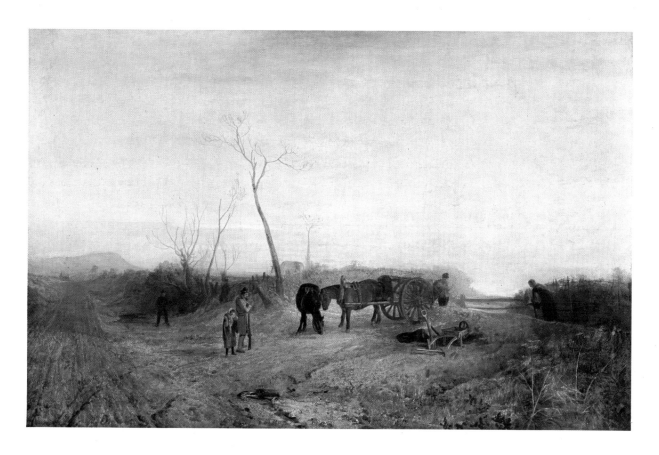

27 *Frosty Morning* exh. 1813
Canvas, $44\frac{3}{4} \times 68\frac{3}{4}$ (113.7 × 174.6)
[492]

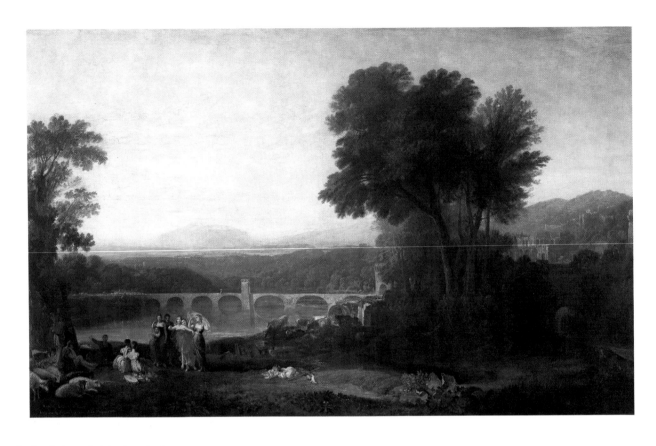

28 *Appulia in search of Appulus* exh. 1814
Canvas, 57 × 93 (144.8 × 236.2)
[495]

29 *Crossing the Brook* exh. 1815
Canvas, 76 × 65 (193 × 165.1)
[497]

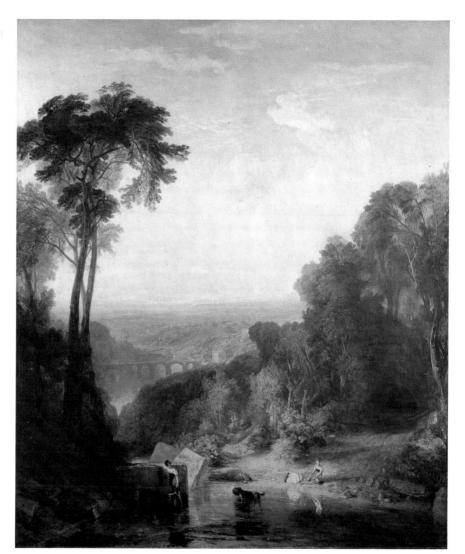

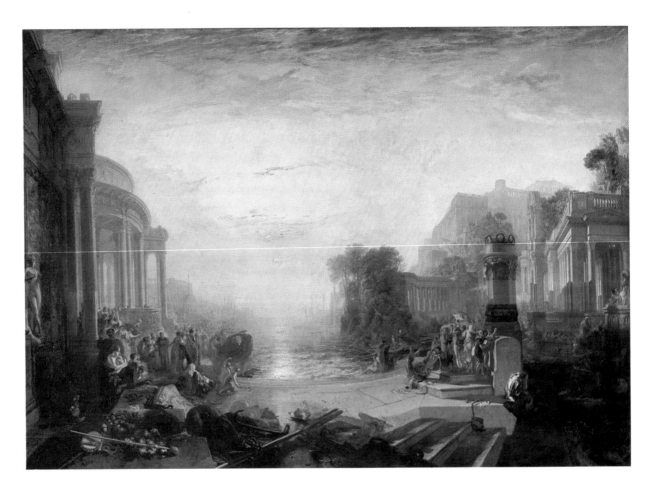

30 *The Decline of the Carthaginian Empire* exh. 1817
Canvas, 67 × 94 (170.2 × 238.8)
[499]

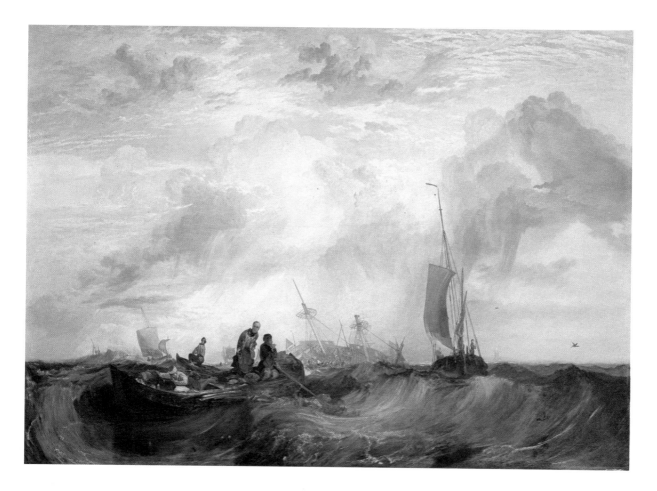

31 *Entrance of the Meuse: Orange-*
Merchant on the Bar, going to Pieces:
Brill Church bearing S.E. by S.,
Masensluys E. by S exh. 1819
Canvas, 69 × 97 (175.3 × 246.4)
[501]

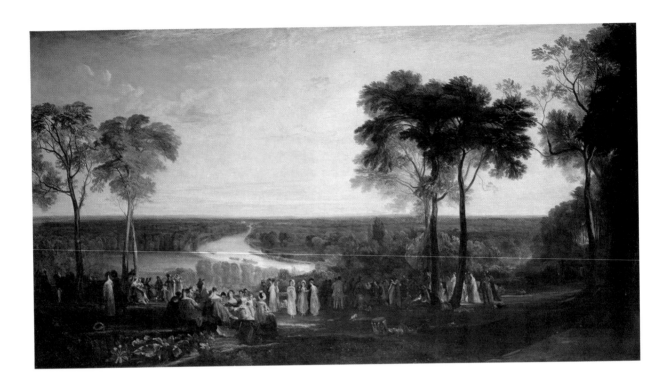

32 *England: Richmond Hill on the Prince
Regent's Birthday* exh. 1819
Canvas, 70⅞ × 131¾ (180 × 334.6)
[502]